320

One note from
One Bird
Is better than
a million words

a scabbard
holds
has one
out-
sword

Emily Dickinson
Envelope Poems

with transcriptions by

Marta L. Werner and Jen Bervin

CHRISTINE BURGIN / NEW DIRECTIONS

As there are
apartments in our
own minds that —
we never enter
without apology —
we should respect
the secrets of
others —

Preface

Although a very prolific poet—and arguably America's greatest—
Emily Dickinson (1830–1886) published fewer than a dozen of
her eighteen hundred poems. She preferred not to, and instead
created her own gatherings of poems into packets later known as
fascicles. When, in her later years, she stopped producing these, she
was still writing a great deal, and at her death she left behind many
poems, drafts, and letters. And it is among the makeshift and fragile
manuscripts of Dickinson's later writings that we find the "envelope
poems" gathered here. (Strictly speaking, some of the envelope
writings collected here are messages or notes rather than poems.)

The earliest envelope poem may have been composed
around 1864, but the majority were probably created from 1870
to 1885, when she was no longer creating her fascicle books
and when she was testing, differently, and for a final time, the
relationship between message and medium.

"What a | Hazard | a Letter | is " Dickinson scrawled in a
late fragment composed in a handwriting so disordered it seems
to have been formed in the dark.

These manuscripts on envelopes (recycled by the poet with
marked New England thrift) are sometimes still referred to as

Manuscript A842, "As there are | apartments in our | own minds"

"scraps" within Dickinson scholarship. But one might think of them as the sort of "small fabric" the poet writes of in one corner of a large envelope: "Excuse | Emily and | her Atoms | the North | Star is | of small | fabric but it | implies | much | presides | yet." When we say small, we often mean less. When Emily Dickinson says small, she means fabric, Atoms, the North Star.

In 1862, she wrote to her future editor Thomas Wentworth Higginson, during a stretch when she was writing three hundred poems a year: "My little Force explodes – " This enigmatic poet, petite by physical standards, is vast by all others. These small envelope poems carry a poignant yet fierce art and, as the poet Susan Howe has remarked, "arrive as if by telepathic electricity and connect without connectives."

Written with the full powers of her late, most radical period, these envelope poems seem intensely alive and charged with a special poignancy—addressed to no one and everyone at once. They remind us of the contingency, transience, vulnerability, and *hope* embodied in all our messages.

The fragments in this book are selected from those reproduced in the complete collection of envelope writings, *The Gorgeous Nothings*, a collaboration between Marta L. Werner, the foremost scholar of Dickinson's late work, and the poet and visual artist Jen Bervin (Christine Burgin/New Directions 2013; Granary Books 2012). Their transcriptions allow us to read the texts, while the facsimiles let us see exactly how Dickinson wrote them (the variant words, crossings-out, dashes, directional fields,

spaces, columns, and overlapping planes)—and absorb the visual and acoustic aspects of the manuscripts: these singular objects balance between poetry and visual art.

When she was only sixteen Emily Dickinson wrote, in a letter to her friend Abiah Root, "Let us strive together to part with time more reluctantly, to watch the pinions of the fleeting moment until they are dim in the distance & the new coming moment claims our attention." *Envelope Poems* claims our attention with a new Emily Dickinson.

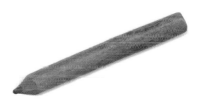

Emily Dickinson sent this miniscule two-inch-long pencil in a letter to the Bowles, "If it had no pencil, | Would it try mine – " (A695), wryly nudging them to write. It was enveloped in a letter folded into thirds horizontally, pinned closed at each side.

A 105

A great Hope
fell
You heard no
noise
crash

The R u i n was
 havoc
within damage

Oh c u n n i n g

W r e c k

That told no

Tale

And let no

Witness in

The mind was

built for

mighty Freight

For dread

occasion planned

How often

foundering

at Sea

Ostensibly , on

Land

A great hope
fell
You heard no
noise
crash
The Ruin was
within
horse damage
Oh cunning
wreck
that told no
tale

And let no
witness in

the mind was
built for
mighty freight
for dread
occasion planned
How often
foundering
at Sea
Ostensibly, on
Land

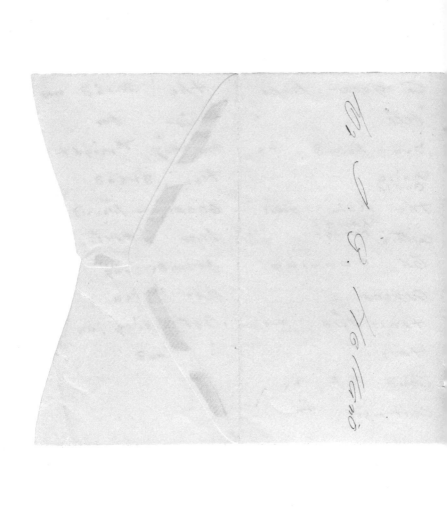

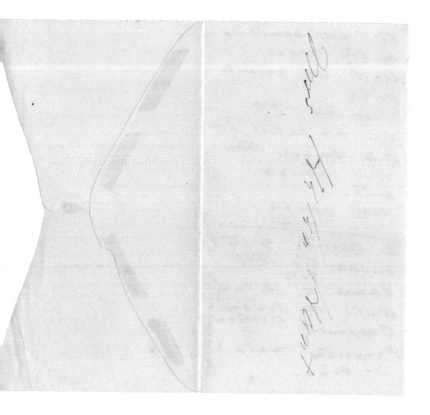

105₂

a not admitting
of the wound
until it grew so
wide
that all my
life had entered it
And ~~troughs~~ there
were trough
beside -
 was space
 rooms

a closing of the
simple lid that
opened to the sun
until the
Carpenter
Perpetual nail
it down -


unsuspecting Carpenters
sole
under
sovereign

A 105a

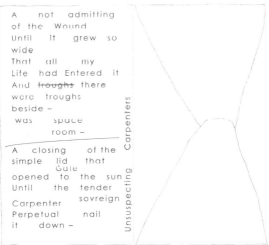

```
A      not    admitting
of  the   Wound
Until    It    grew   so
wide
That   all     my
Life   had  Entered   it
And   troughs  there
were   troughs
beside –
  was     space
        room –
```

Carpenters

```
A     closing     of the
simple    lid    that
        Gate
opened   to   the   sun
Until    the   tender
Carpenter    sovreign
Perpetual    nail
it    down –
```

Unsuspecting

A 128

All men for Honor
hardest work
But are not known
to earn –
Paid after they have
ceased to work
In Infamy or Urn –

All men for Honor
hardest work
But are not known
To earn —
Paid after they have
ceased to work
In Infamy or earn —

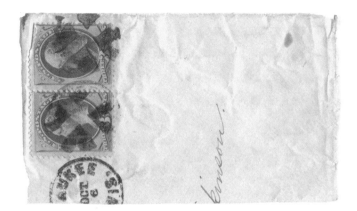

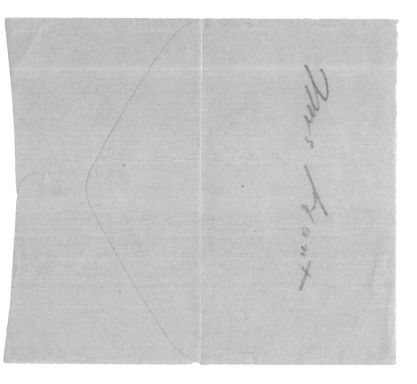

As old as Woe—
How old is that?
Some eighteen
thousand years—
As old as
Bliss
Joy—
How old is
that or
the age of that
they are of
equal years—

Together
Chiefest—they
Chiefly
are found

But—the seldom
side by side—
not, from
neither of
them tho'
he hit
Can
may
human

nature
hide

A 139

As old as Woe –
How old is that ?
Some Eighteen
thousand years –
As old as
Bliss
Joy –
How old is
that or
The age of that
They are of
Equal years –

Together
Chiefest they
 Chiefly
 are found

But tho seldom
 side by side –
not From
 neither of
 them tho'
 he try
 can
 may
 Human
 Nature
 hide

Death warrants are
supposed to be
believed to be me
An Enginery of
Equity
 hazardous
A merciful mistake
 A pencil in
 dainty
 an Idol's Hand
 A Devotee has
 oft consigned
 To Crucifix
 or Block
 stake

bland - cool

Death warrants are
supposed to be
believed to be ~~be well~~
an Engineers of
Equity hazardous mistake
a merciful
a pencil in
saint Hard 610
an Idiots
a Devotee has
oft consigned
to Crucifix
or Block 600
Stake

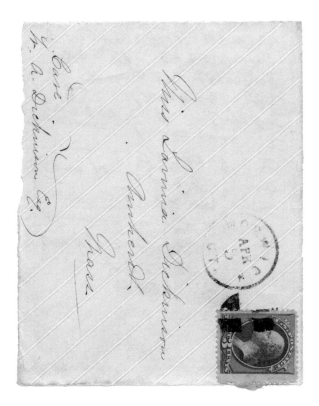

Miss Annie Dickinson
Amherst
Mass

E. Case
& R. Dickinson Esq

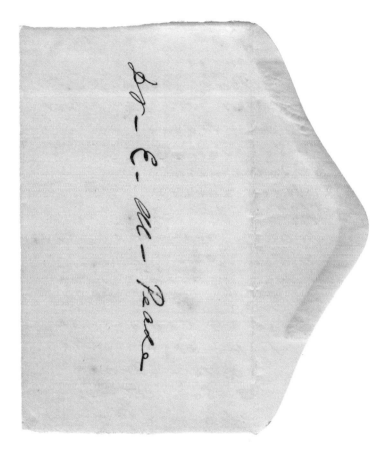

Dr. E. M. Peace

Had we our
senses
But tho' perhaps 'tis
well they're not
at Home
So intimate with
madness
He's liable with them
that's 'tis

Had we the eyes
within our Head -
How prudent well that
we are Blind.
We could not
look opon The
Earth - would
So utterly
unmoved -

A 202

Had we our
senses
 tho'
But perhaps 'tis
well they're not
at Home
So Intimate with
Madness
He's liable with them
That's'
'Tis

Had we the eyes

within our Head s
 prudent
How well that
 we are Blind –
 We could not
look opon the
Earth – World

 So So Utterly
 Unmoved –

A 232

I have no
life ~~to~~ but ~~live~~ this
~~But~~ To lead
it here but
Nor any
Death but
lest this
 dispelled
+Abased from
there –

Nor + Plea
for World s
to come
+Nor Wisdoms
new
Except through
this + Extent

The loving
 you –
 + Withheld –
 deprived
 from
 there –
+ Nor tie to

+ Expanse –

I have no
life but ~~out this~~
~~But~~ to lead
it here
Nor any
death but out
lest dispelled
+ Abased from
There -

Nor + plea
for World s
+ to come
+ Nor Wisdoms
new
Except through
This + Extent

the loving
sou-
+ Withheld.
deprived
from
there.
Nor tie to
+ Expanse -

Miss Emily Dickinson
care of M.E. Dickinson Esq
Amherst
Mass

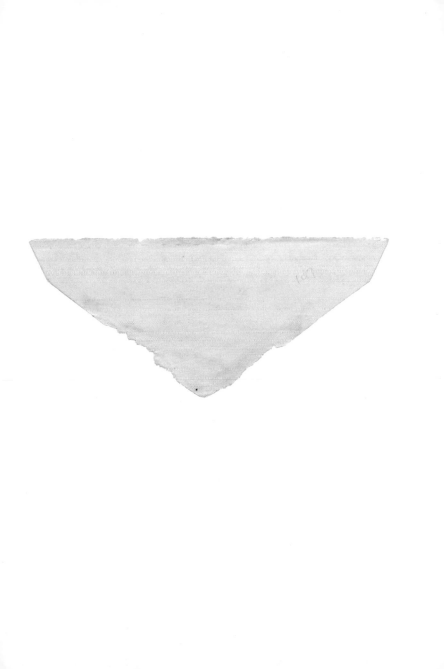

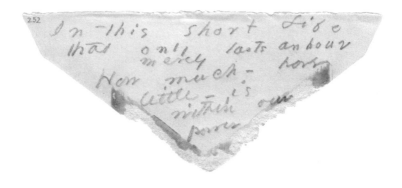

252

In this short life
that only lasts an hour
merely
How much — how
little — is
within our
power

Λ 252

In this short Life
that only lasts an hour
merely

How much – how
little – is
within our
power

A 277

Long Years
 apart – can
 make no
 Breach a
 second cannot
 fill –
+The absence
 a
 of the Witch
 cannot
 does not
 Invalidate
 a
 the spell –
+

Who says
the Absence
 of a
 Witch
In –vali/dates
his spell?
The embers
of a
Thousand
 Years
 years
 Uncovered
 by the Hand

Long Years
apart - can
make no
Breach a
second cannot
fill -
+ the absence
a of the witch
does not
Invalidate
a the spell -
+

Who says
the absence
of a
witch
In -validates
his spell?
The embers
of a
Thousand
years
years
Uncovered
of the Hand

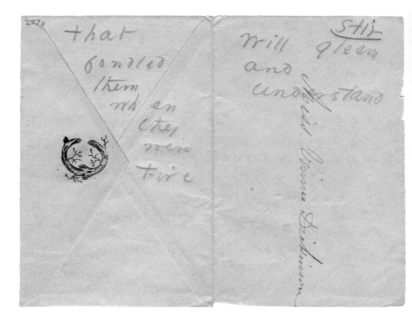

2273

that
fondled
them
when
they
were
fire

Stir
gleam
will
and
understand

With Love Emma Dickinson

A 277

That
fondled
them
wh en
they
were
Fire

stir
WIll gloam
and
understand

A 278

L o o k b a c k

o n T i m e

w i t h k i n d l y

 E y e s –

H e d o u b t l e s s

d i d h i s b e s t –

H o w s o f t l y
 his
s i n k s t h a t

t r e m b l i n g S u n

I n H u m a n

N a t u r e 's W e s t –

278

Look back
on time,
with kindly
eyes—
He doubtless
did his best—
How softly
 his
sinks that
trembling sun
In Human
Nature's Nest—

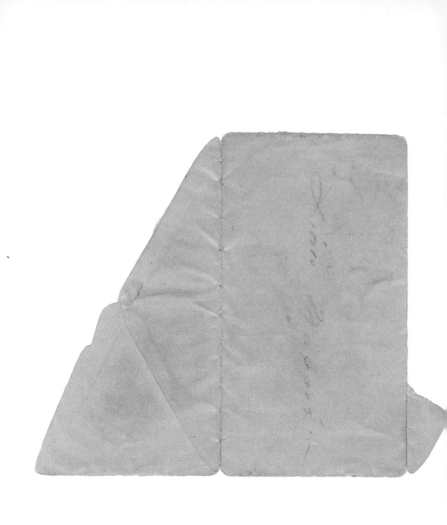

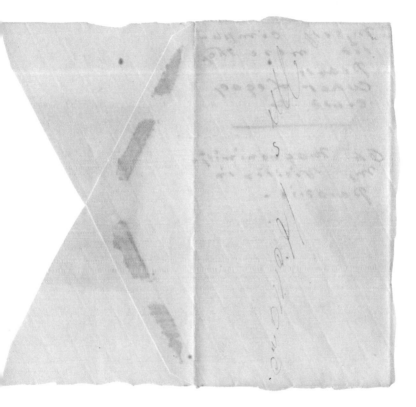

313
314

Myself compelled
were the
Pearls
What Legacy
could be

Oh Magnanimity.
My Visitor in
Paradise -

A 313 / 314

Myself compu-
ted were they
Pearls
What Legacy
could be

Oh Magnanimity –
My Visitor in
Paradise

A 316

Oh Sumptuous
moment
Slower go
~~Till~~ + That I
 Till
may gloat on
can
thee –
'T w i l l never
be the same
to starve
Now that I abundance
since
see –
Which was to

famish , then or
now –
The difference
of Day
 to
A s k him
unto the Gallows
led – called
With morning
By
in the Sky

Oh Scrupulous vanish, then or
moment ~~this~~
Slower go the difference
~~twice~~ ~~all~~ That I of ~~Day~~
 Tide to
may gloat on Ask him
can
thee – into the ballad
Twice never ed – called
to the same with morning
to stars By
now that I abundance in the sky
since
see –

Which was 1st

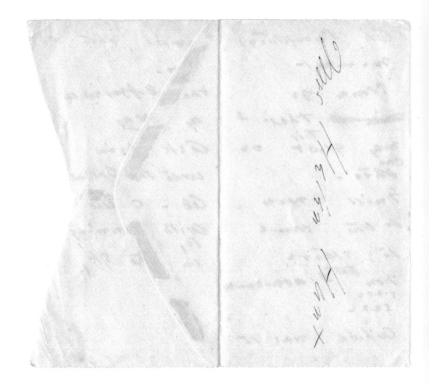

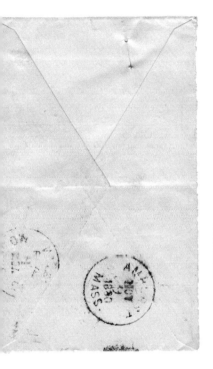

317

On that
specific Pillow
Our projects
flit away-
the Nights'
tremendous
Morrow
And whether
Sleep will stay.
Or usher us-
a Stranger-

317a

+ to Situations
New
the effort
× to comprise
it
Is all the
Soul can do,
+ Exhibition
Comprehension
+ of Comprising

A 317

On that
specific Pillow
Our projects
flit away –
The Nights'
Tremendous
Morrow
And whether
Sleep will stay
Or usher us –
a Stranger –

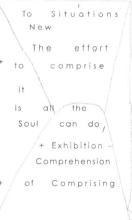

To Situations
New
 The effort
+ to comprise
 it
Is all the
Soul can do
 + Exhibition –
 Comprehension
+ of Comprising

47

A 320

```
One      note  from
One      Bird
Is       better   than
a        million  words
A        scabbard
         needs
has  –   holds
but  one
sword
```

One note from
One Bird
Is better than
a million notes
a scabbard
notes holds
has-
out-
one
sword

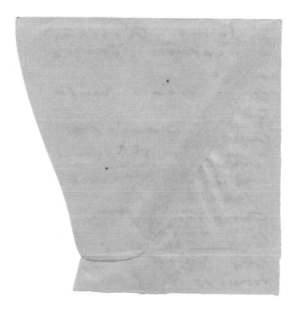

Some wretched
creature, savior
take
who would [nought?]
to die
And leave us
[very?] sweet-
mercy's sake
patience, hour
Another hour
to me
 human
my earthly
 Life
Hour to me

Λ 355

Some Wretched
creature , savior
take
Who would Exull
to die
And leave for
thy sweet
mercy's sake
patience'
Another Hour
to me
 human
My Earthly
 Life
Hour to me

A 394 / 394a

The fairest Home I ever
knew
was founded in an Hour
By Parties also that I knew
A spider and a Flower –
A manse of mechlin and
of Floss – Gloss – Sun –

the fairest Home I ever
knew was founded in an Hour
By Parties also that I knew
a Spider and a Flower —
a manse of mechlin and
of Adamant — Glass — Sand —

Accept my timid happiness
no Joy can be in vain
but adds / [illegible] to some bright
sweet

Emilie Dickinson

A 394 / 394 a

Accept my timid happiness

no Joy can be in vain

but adds to some bright
 sweet

whose dwelling

A 438

The Spry Arms
of the Wind
If I could
crawl between
I have an Errand
imminent
To an adjoining
Zone –
I should not
care to stop,
My Process is
not long

The Wind could
wait without the
Gate
Or stroll the
Town among –
~~Be~~ To ascertain
the House
 if soul's
And is the soul
within
at Home
And hold the
Wick of mine to
it
The long Arms

The Spry Arms
of the Wind
If I could
crawl between
I have an errand
imminent
to an adjoining
Zone —
I should not
care to stop
My Process is
not long

the Wind could
wait without the
Gate
Or stroll the
Town among.
To ascertain
the House
And is the Soul
within
at Home
And hold the
Wick of mine to
it —

438a

to light, and
then return.

Miss Emily Dickinson

A 438

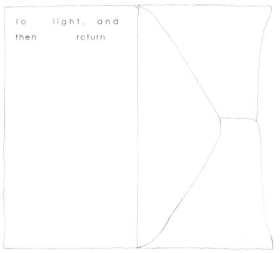

lo light, and
then return

A 450

 The way
 Hope builds his
 House
It is not with a sill –

Nor Rafter –⁺has that

Edifice mars – knows

But only Pinnacle –

_____ _____ _____

Abode in as supreme

This Superticies

As if it were of

Ledges smit

Or mortised with the

And

Laws –

the rat

Hope builds his
House

450

It is not with a sill -
nor Rafter - has that
Edifice mars - Knows
But ony Pinnacle -

_____ _____ _____

Abode in as supreme

this Superficies

As if it were of

Ledges smit with the

Or morticed with the

And

Laws -

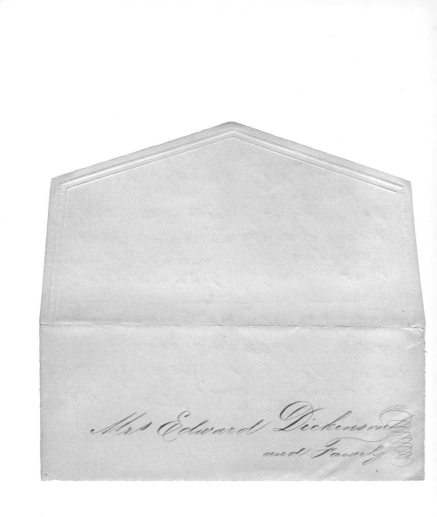

Mrs Edward Dickinson
and Family

Miss Emily Dickinson,
Care Hon. Edward Dickinson,
Amherst,
Mass.

through what
transports of
Patience
I reached the
stolid Bliss
to breathe my
Blank without
thee
Attest me this
and this -
By that bleak
exultation
I won as
near as this
Thy privilege
of Dying
Abbreviate me
this
Remit me this
and this

A 479

Through what
transports of
 Patience
 I reached the
 stolid Bliss
 To breathe my
 Blank without
 thee
 Attest me this
 and this –
 By that bleak
 Exultation
 I won as
 near as this
 Thy privilege
 of dying
Abbreviate me
 this
Remit me this
 and this

A 496 / 497

Tried always
and Condem
ned by thee
Permit me
this reprieve
allow –
bestow – +
That dying +I
may earn
the look

Lives he in any
other world faith cannot
my reply
Befo re it was
imperative all
twas to
distinct
me –
All
distinct
was
distinct

tried almost
and condem
ned by the
permit me
this reprieve
allw—
destroying
that earn
may look
the look

gave

for which

I cease to

live –

A 496 / 497

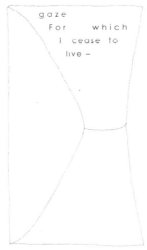

gaze
For which
I cease to
live –

A 499

'Twas later when
the summer went
Than when the
Cricket came –
And yet we knew
that gentle Clock
Me ant nought but
 Going Home –
 'Twas sooner when
 the Cricket went
 Than when the
Winter came
Yet that pa –
 thetic Pendulum
 m
 Keeps
 Esoteric
 Time–
 e

'twas later when
the summer went
than when the
Cricket came -
And yet we knew
that gentle Clock
Meant nought but
going Home -
'Twas sooner when
the Cricket went
than when the
Winter came
Yet that pa-
thetic Pendulum
keeps
Esoteric
time

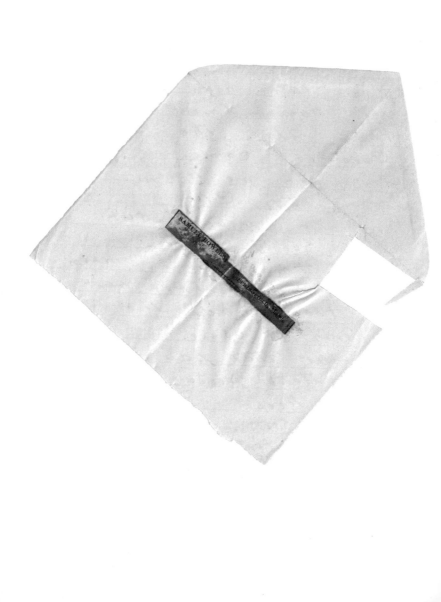

Mr. & Mrs. Edward Dickinson

531 Without a smile -
Without a throe

x A Summer's soft
Assemblies go
to their entrancing
end
Unknown - for all
the times we met -
& stranger whomever
intimate -
What a dissembling
friend -
+ No - our -
Nature's soft

A 531

Without a smile –
Without a Throe

+A Summer's soft
Assemblies go
To their entrancing
end
Unknown – for all
the times we met –
Estranged , however
intimate –
What a dissembling
Friend –
+ Do – our –
 Nature's soft

A 539 / 539a

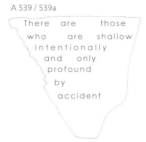

There are those
who are shallow
intentionally
and only
profound
by
accident

There are those
who are shallow
intentionally
and only
profound
by
accident—
—

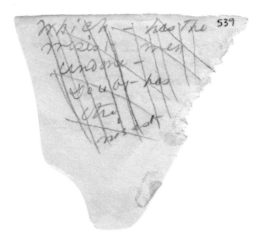

539

A 539 / 539a

Which has the
wisest men
Undone
Doubt has
the
wisest

A 758 / 758a

Thank you for
Knowing I did
not spurn it,
because it was
 true – I did not–
 refused
 I denied what Mr
 Erskine said not
 from detected feeling
 but of myself
 it was not true –
 I ~~can not~~ suppose
 not of others

758

thank you for
knowing I did
not spurn it
because it was
... did not —
I denied when my
Erskine said not
... feeling
out — if myself
it was not true —
I cannot suppose
not of others

It is got to be
with you oreayu
near
I look sou-
neccing makes a
distinction as cair
as tonigno I do not
know the rasply
woura lovall sou
like a sig I hou
men cite cory

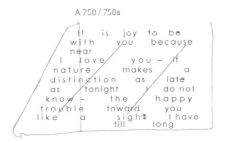

It is joy to be
with you because
near
I love you – if
nature makes a
distinction as late
as tonight I do not
know – the happy
trouble toward you
like a sigh I have
till long

A 821

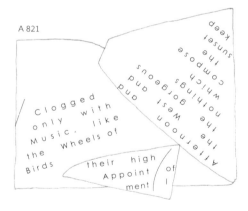

Clogged
only with
Music, like
the Wheels of
Birds

their high
Appoint
ment

of
I

the afternoon
the west and
and
nothings
gorgeous
which
compose
the
sunset
keep

clogged with
only lie like
music, like
the wheels
Birds there

As there are
apartments in our
own minds that
we never enter
without apology,—
we should respect
the seals of
others.

A 842

As there are
Apartments in our
own Minds that –
we never enter
without Apology –
we should respect
the seals of
others –

which –

A 843

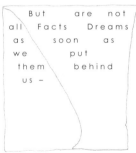

But are not
all Facts Dreams
as soon as
we put
them behind
us –

But are not
all facts dreams
as soon as
we put
them behind
us.

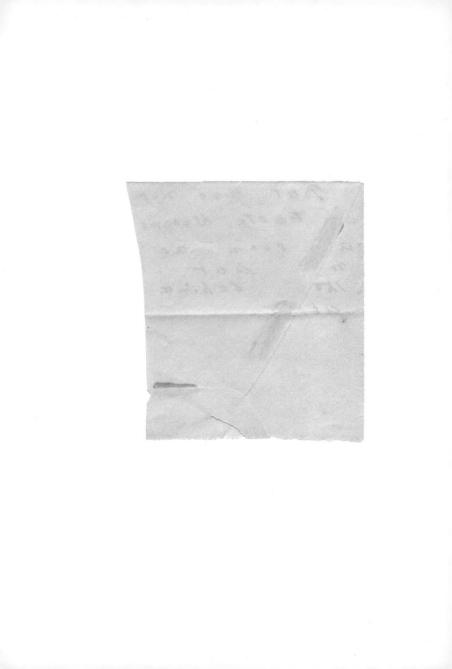

Acknowledgments

Envelope Poems presents a small selection of facsimile reproductions of Emily Dickinson's envelope writings. This edition is drawn from and based upon Marta L. Werner and Jen Bervin's *The Gorgeous Nothings*, published as a Christine Burgin/ New Directions co-publication in 2013. A limited edition of *The Gorgeous Nothings* was originally published by Steve Clay of Granary Books in 2012. Both editions of *The Gorgeous Nothings* reproduce the Dickinson manuscripts at actual size. For the purpose of this edition the manuscript reproductions are slightly smaller. Christine Burgin and New Directions wish to thank all those involved in the creation of these original editions especially Jen Bervin and Marta L. Werner; Steve Clay of Granary Books; Margaret Dakins, Archives & Special Collections Specialist, Frost Library, Amherst College; and Michael Kelly, Head of Archives & Special Collections, Frost Library, Amherst College.

The Publishers gratefully acknowledge the sources for this volume's brief preface: almost every line has been adapted from the original essays by Marta L. Werner, Jen Bervin, and Susan Howe featured in *The Gorgeous Nothings*.

Manufactured in China

Christine Burgin/New Directions Books are printed on acid-free paper.
First published as a Christine Burgin/New Directions Book in 2016

Design and composition by Laura Lindgren

Library of Congress Control Number: 2015047826

ISBN 978-0-8112-2582-3

New Directions Books are published for James Laughlin
by New Directions Publishing Corporation
80 Eighth Avenue, New York, NY 10011

Christine Burgin Books are published by
The Christine Burgin Gallery
239 West 18th Street, New York, NY 10011